Goose
Goes to School

白鵝小菇去上學

Laura Wall

新雅文化事業有限公司
www.sunya.com.hk

新雅・點讀樂園 *Goose*（白鵝小菇故事系列）

　　本系列共 6 冊，以貼近幼兒的語言，向孩子講述小女孩蘇菲與白鵝小菇的相遇和生活點滴。故事情節既輕鬆惹笑，又體現主角們彌足珍貴的友誼，能感動小讀者內心的柔軟，讓他們學懂發現生活中的小美好，做一個善良、溫柔的孩子。

　　此外，內文設有中、英雙語對照及四語點讀功能，包括英語、粵語書面語、粵語口語和普通話，能促進幼兒的語文能力發展。快來一起看蘇菲和小菇的暖心故事吧！

如何啟動新雅點讀筆的四語功能

　　請先檢查筆身編號：如筆身沒有編號或編號是 SY04C07、SY04D05，請先按以下步驟下載四語功能檔案並啟動四語功能；如編號第五個號碼是 E 或往後的字母，可直接閱讀下一頁，認識如何使用新雅閱讀筆。

1. 瀏覽新雅網頁 (www.sunya.com.hk) 或掃描右邊的 QR code 進入 。

2. 點選 。

3. 依照下載區的步驟說明，點選及下載 *Goose*（白鵝小菇故事系列）框目下的四語功能檔案「update.upd」至電腦。

4. 使用 USB 連接線將點讀筆連結至電腦，開啟「抽取式磁碟」，並把四語功能檔案「update.upd」複製至點讀筆的根目錄。

5. 完成後，拔除 USB 連接線，請先不要按開機鍵。

6. 把點讀筆垂直點在白紙上，長按開機鍵，會聽到點讀筆「開始」的聲音，注意在此期間筆頭不能離開白紙，直至聽到「I'm fine, thank you.」，才代表成功啟動四語功能。

7. 如果沒有聽到點讀筆的回應，請重複以上步驟。

如何使用新雅點讀筆閱讀故事？

1. 下載本故事系列的點讀筆檔案

1. 瀏覽新雅網頁 (www.sunya.com.hk) 或掃描右邊的 QR code 進入 新雅・點讀樂園 。

2. 點選 下載點讀筆檔案 ▶ 。

3. 依照下載區的步驟說明，點選及下載 *Goose*（白鵝小菇故事系列）的點讀筆檔案至電腦，並複製至新雅點讀筆的「BOOKS」資料夾內。

2. 啟動點讀功能

開啟點讀筆後，請點選封面右上角的 新雅・點讀樂園 圖示，然後便可翻開書本，點選書本上的故事文字或圖畫，點讀筆便會播放相應的內容。

3. 選擇語言

如想切換播放語言，請點選內頁左上角的 ENG 粵 ☆ 普 圖示，當再次點選內頁時，點讀筆便會使用所選的語言播放點選的內容。

4. 播放整個故事

如想播放整個故事，請直接點選以下圖示：

5. 製作獨一無二的點讀故事書

爸媽和孩子可以各自點選以下圖示，錄下自己的聲音來說故事！

1. 先點選圖示上 爸媽錄音 或 孩子錄音 的位置，再點 OK，便可錄音。

2. 完成錄音後，請再次點選 OK，停止錄音。

3. 最後點選 ▶ 的位置，便可播放錄音了！

4. 如想再次錄音，請重複以上步驟。注意每次只保留最後一次的錄音。

爸媽請使用這個圖示錄音

 孩子請使用這個圖示錄音

Today Sophie is going to school.

今天蘇菲要上學。

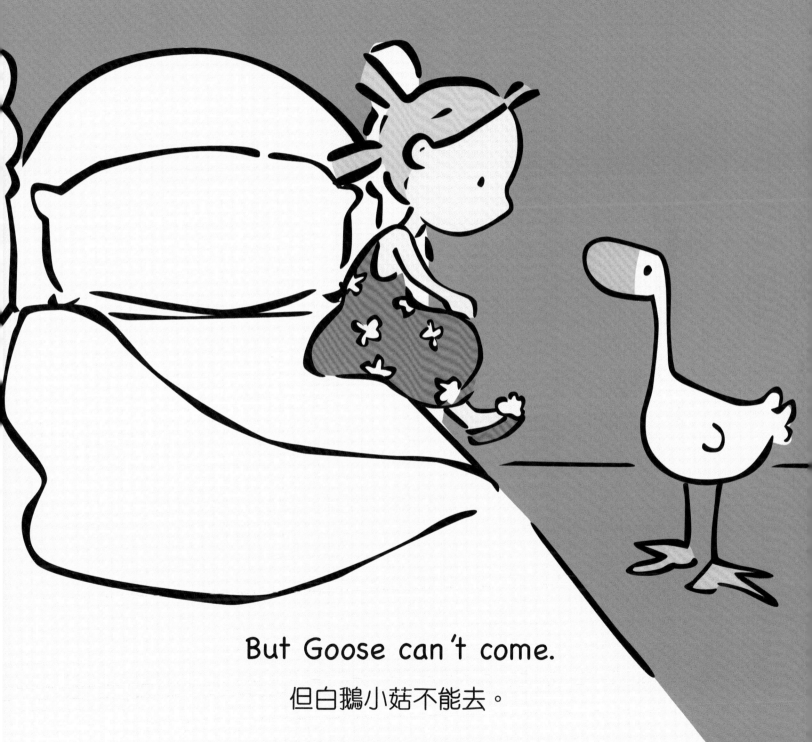

But Goose can't come.

但白鵝小菇不能去。

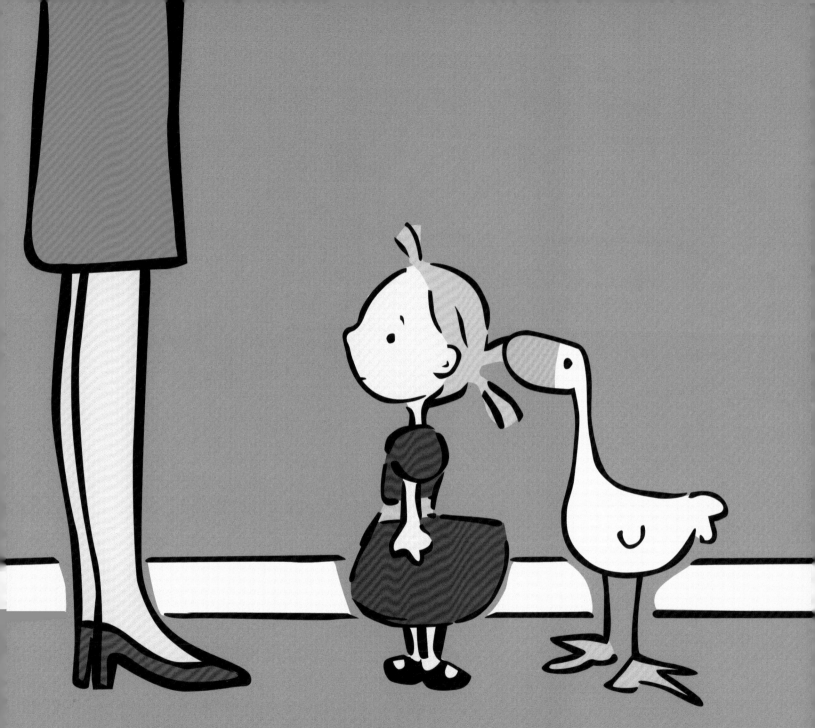

Mum says geese aren't allowed in school.

媽媽說學校裏不許有鵝。

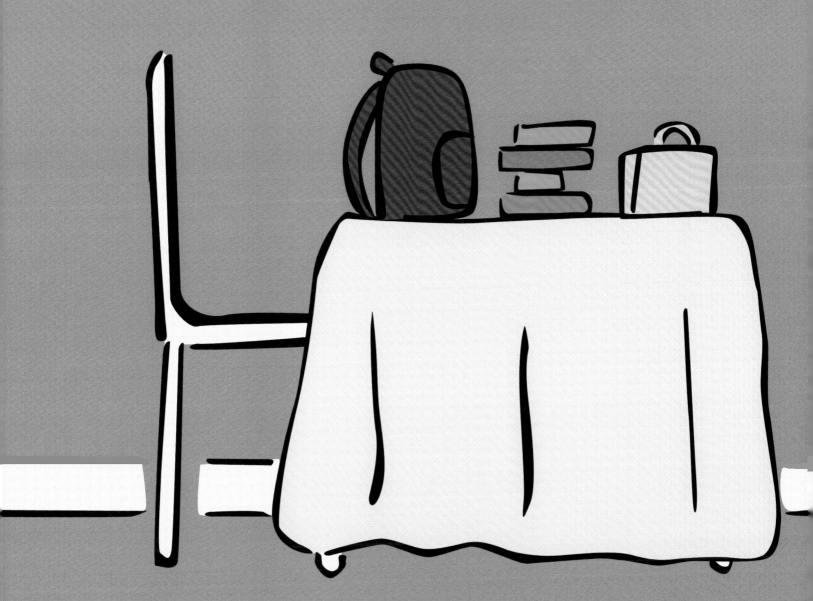

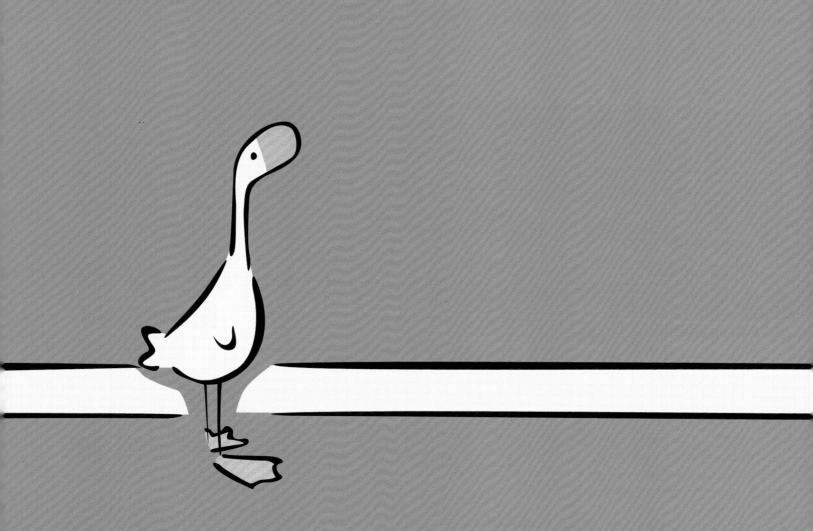

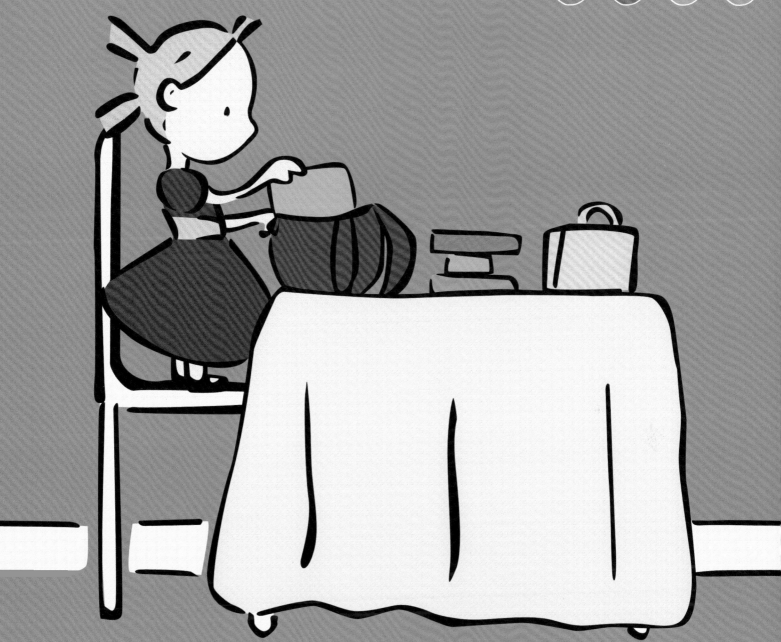

So Sophie packs her bag ready to go.

於是蘇菲把書包收拾好，準備出門。

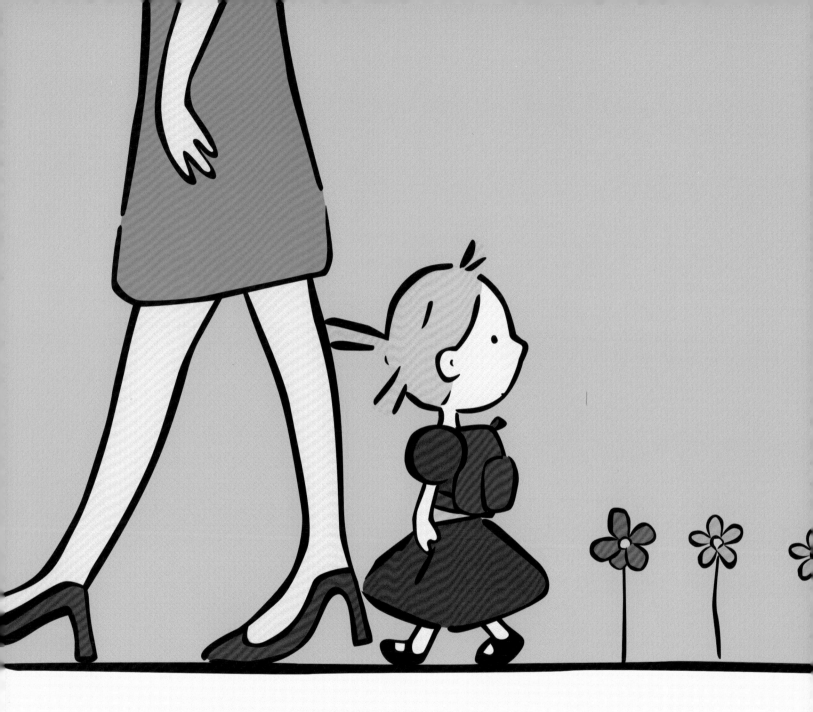

Sophie and Mum walk to school.

蘇菲和媽媽一起走路去學校。

"Goodbye, Goose!"

「再見了，小菇！」

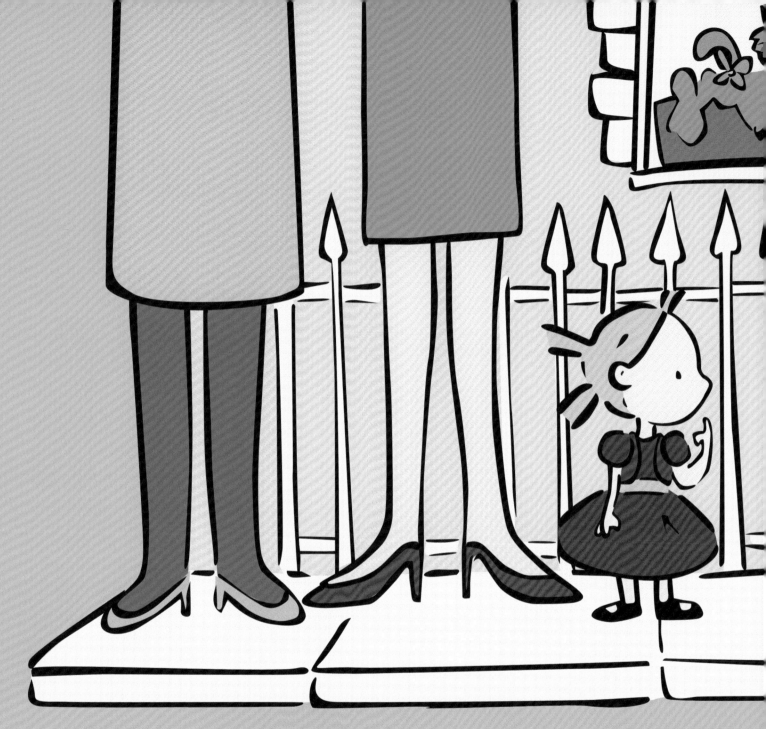

But on the way to school, Sophie thinks

在去學校的路上，蘇菲好像

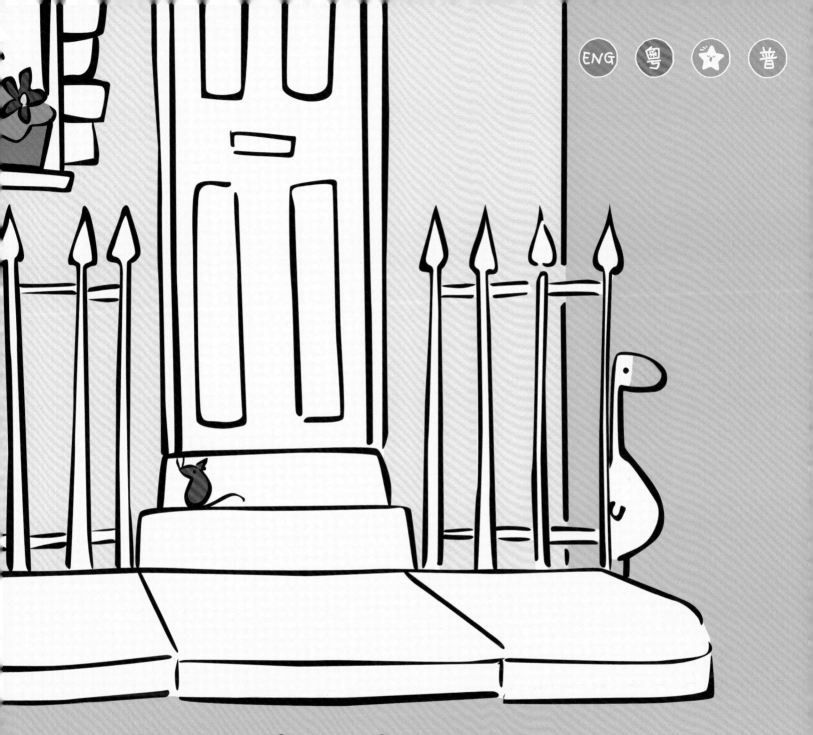

ENG 粵 ⭐ 普

she hears flappy footsteps behind her.

聽見後面有啪嗒啪嗒的腳步聲。

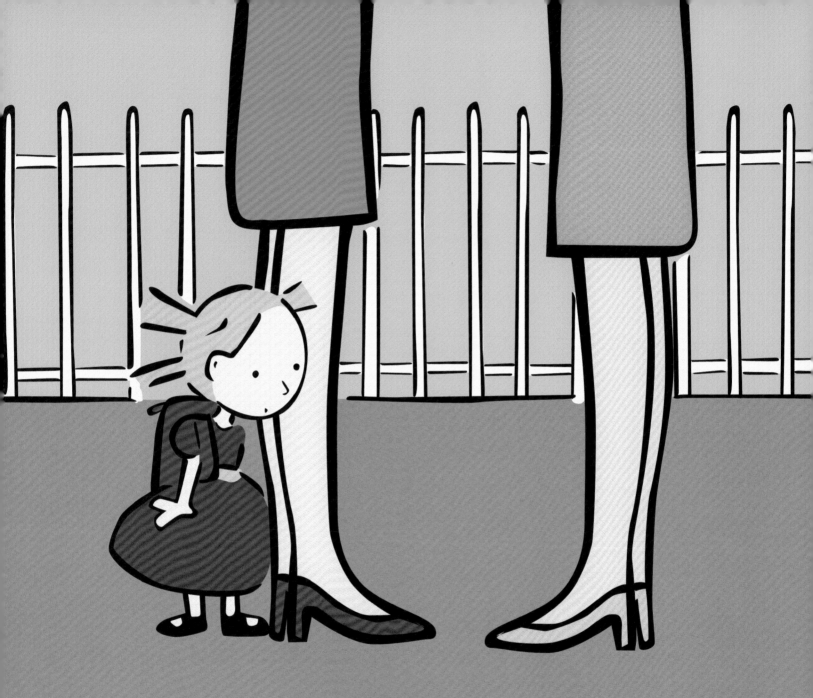

And when she gets to the playground...

當蘇菲走到操場時……

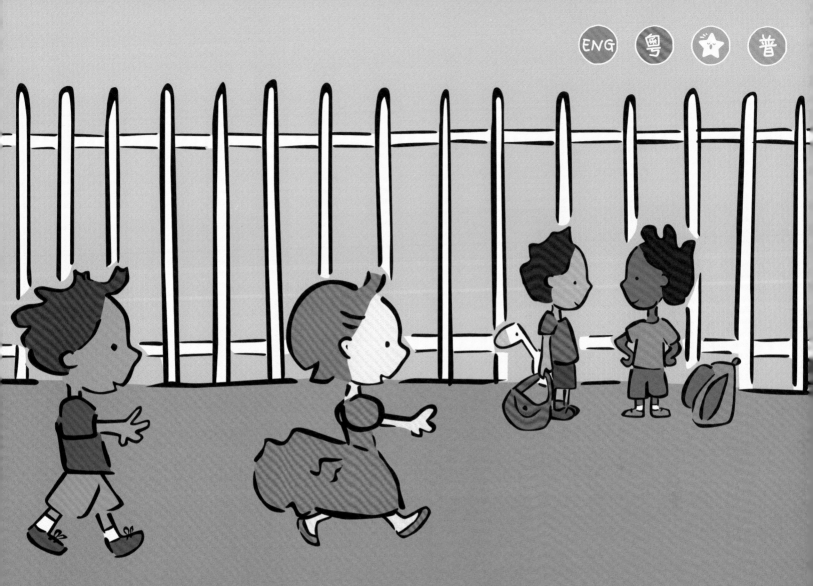

... she is sure she sees a familiar face.

她肯定自己看到一張熟悉的面孔。

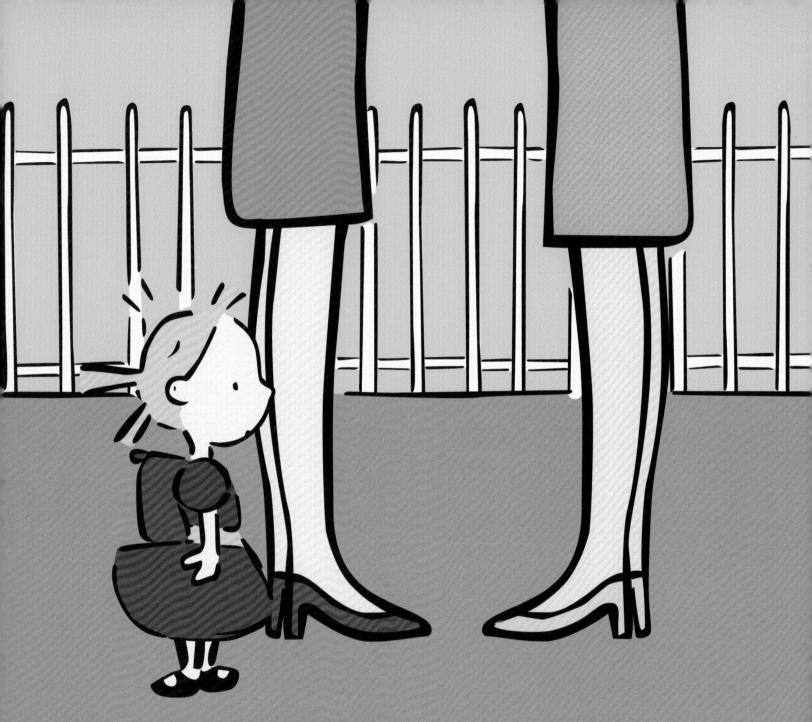

But it can't be Goose, can it?

是小菇嗎？怎可能？

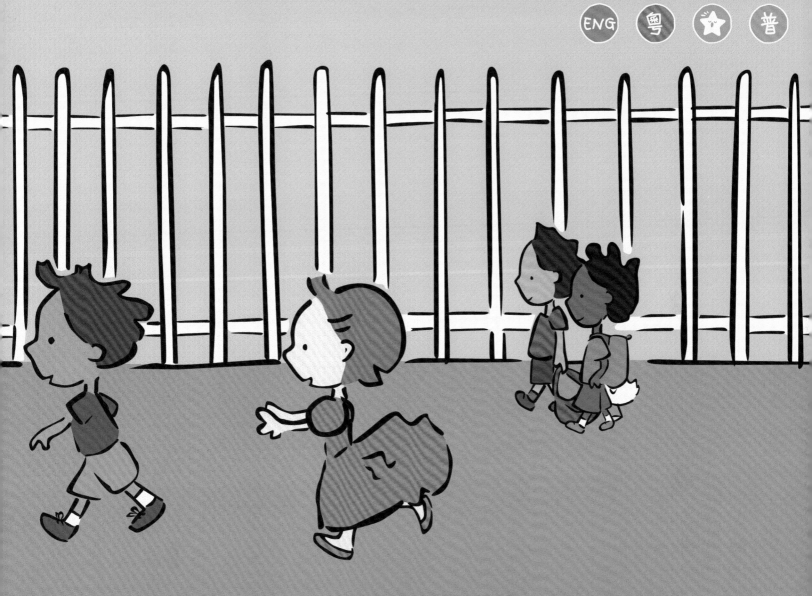

Mum said geese don't go to school.

媽媽說鵝是不會去學校的。

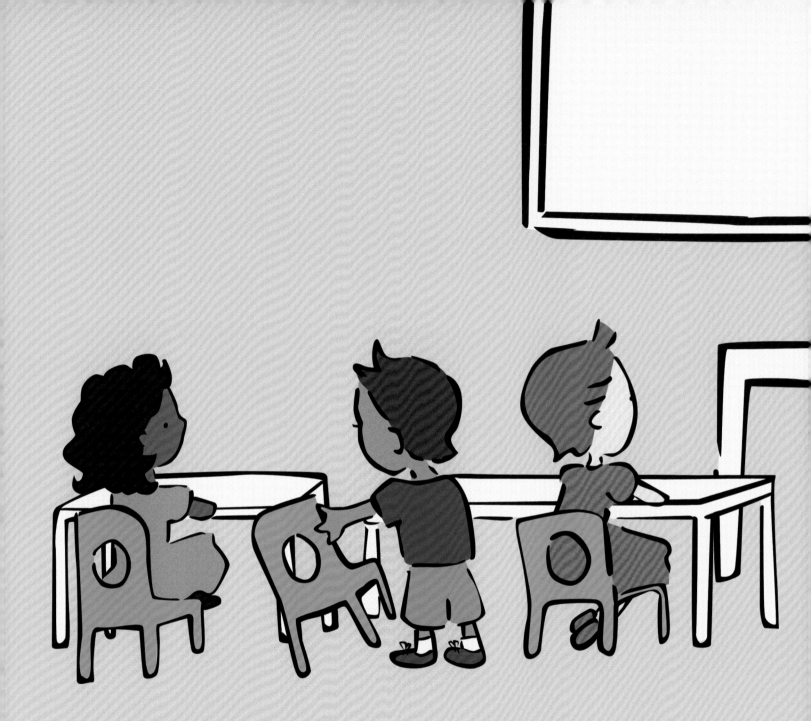

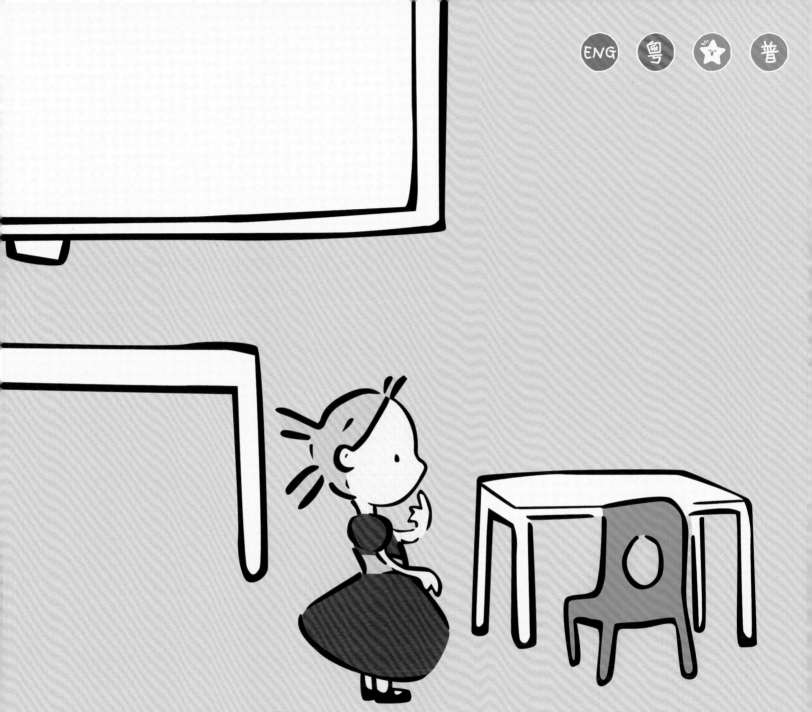

Sophie goes into class and finds her chair.

蘇菲走進課室，找到自己的座位。

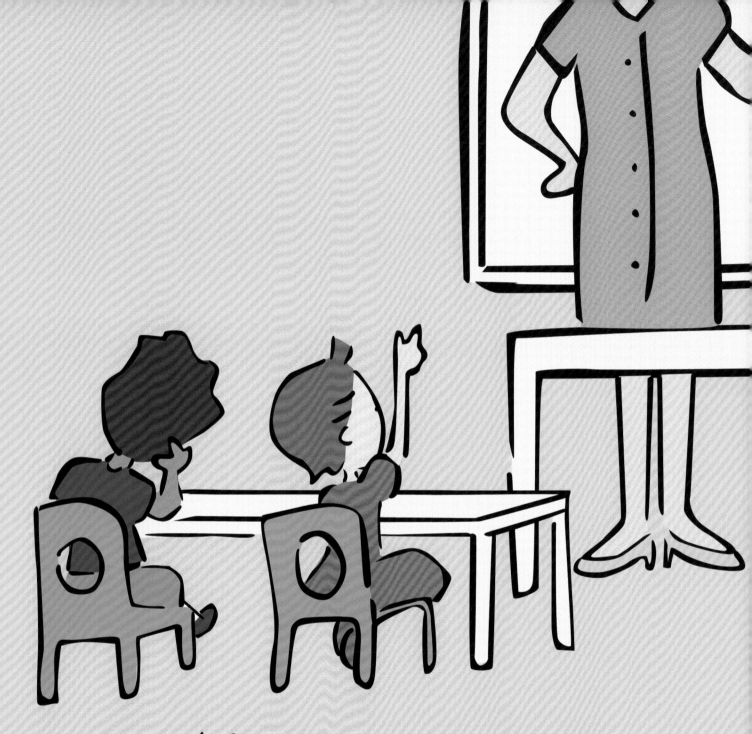

Sophie's first lesson is the alphabet.

蘇菲的第一堂課是認識字母。

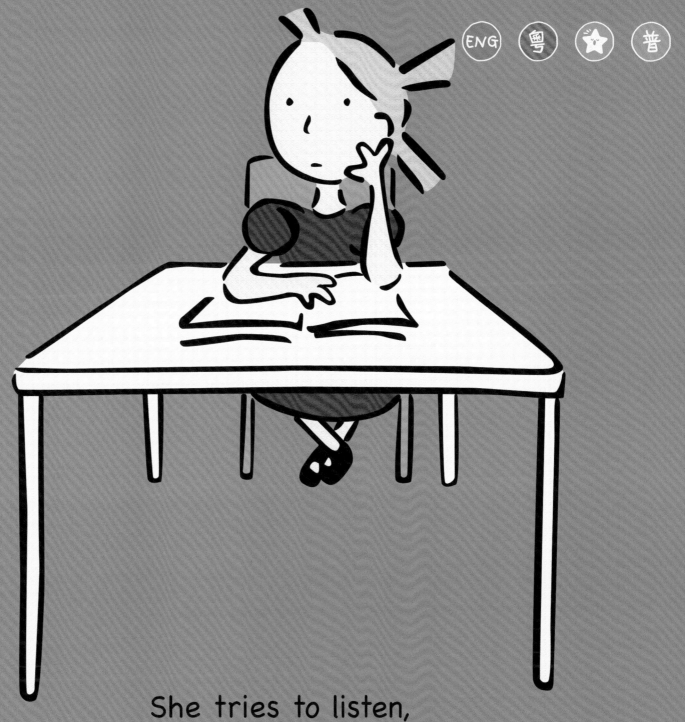

She tries to listen,
but she wishes Goose was with her.

她努力地聽課，但她多麼希望有小菇陪她。

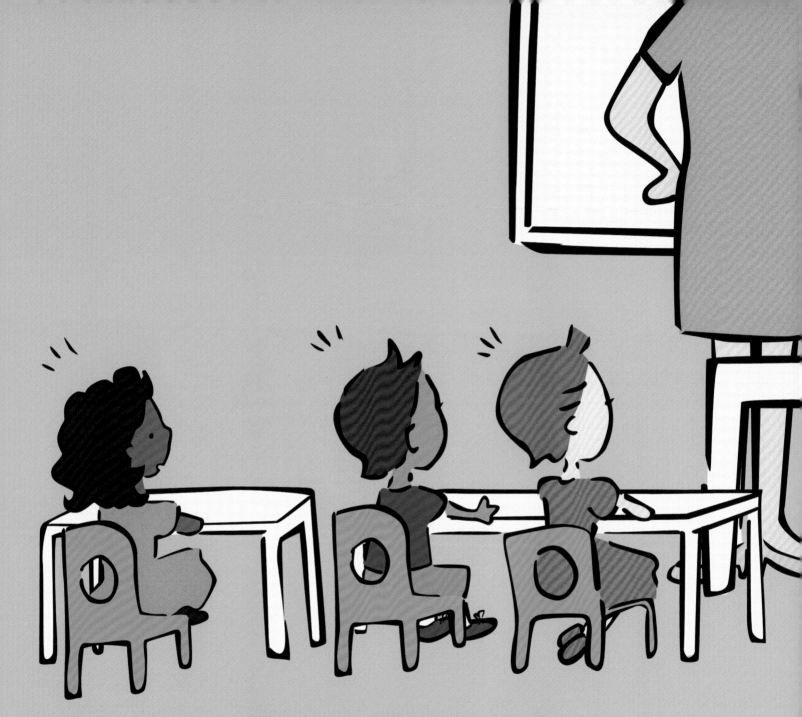

But wait. What's that?

等等，那是什麼？

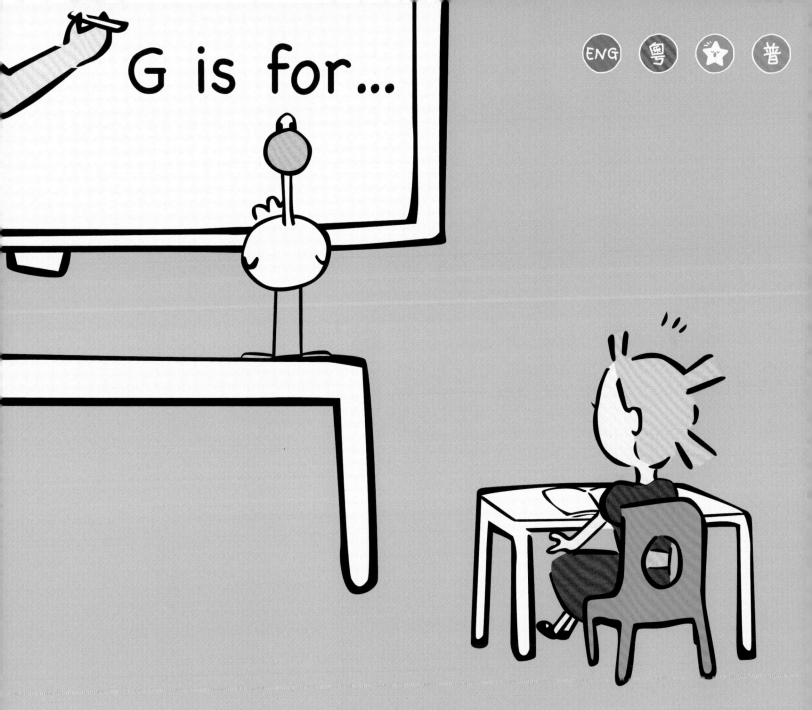

It can't be Goose. Can it?

是小菇嗎？怎可能？

G is for...

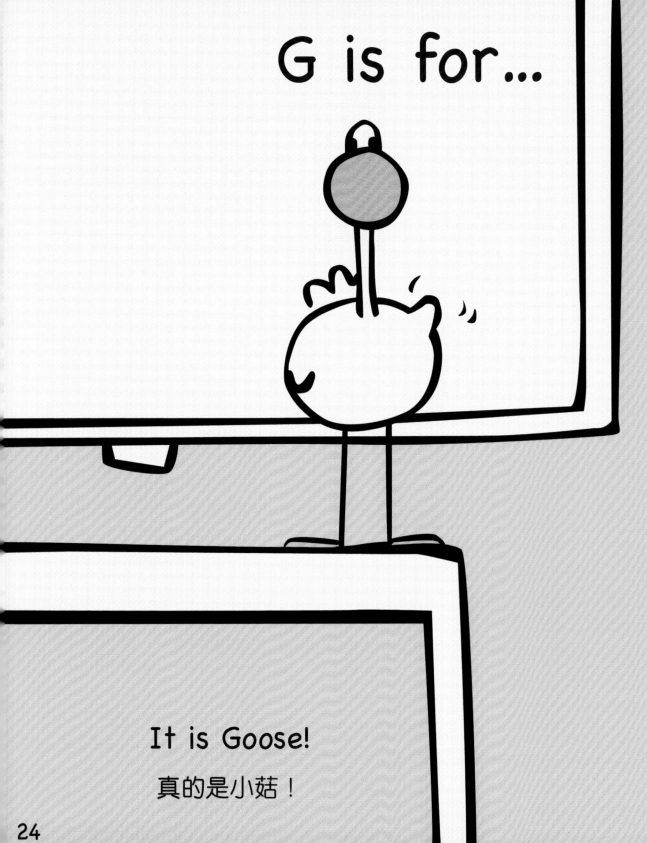

It is Goose!

真的是小菇！

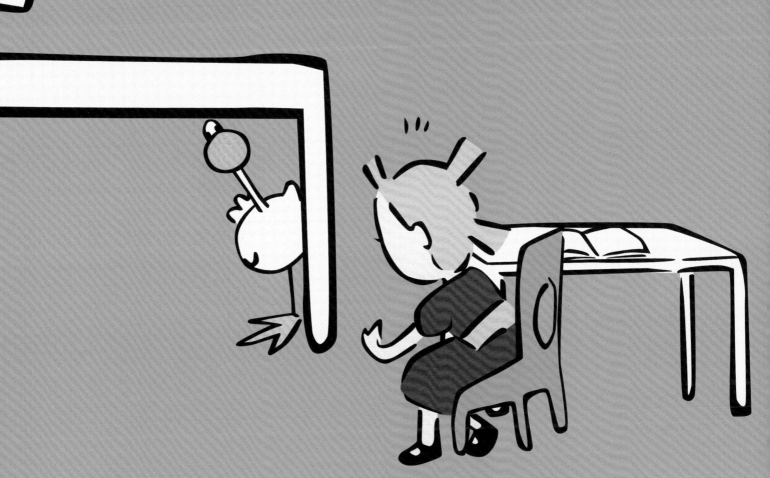

G is for...

ENG 粵 ⭐ 普

"Quick, Goose! Hide under the table."

「快，小菇！躲到書桌下！」

The children start to giggle.

同學們開始咯咯地笑個不停。

G is for...

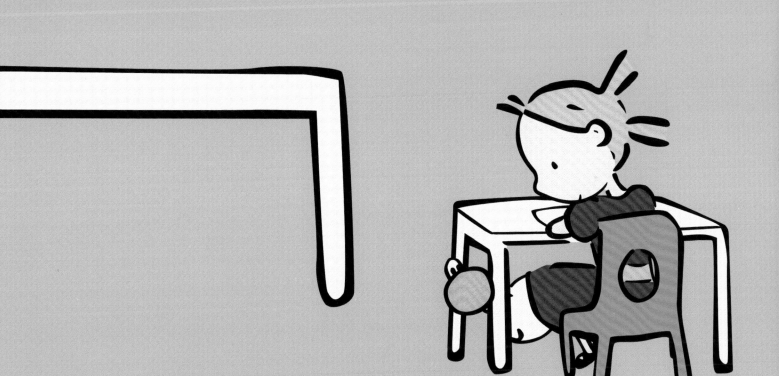

And the teacher gets cross.

然後老師生氣了。

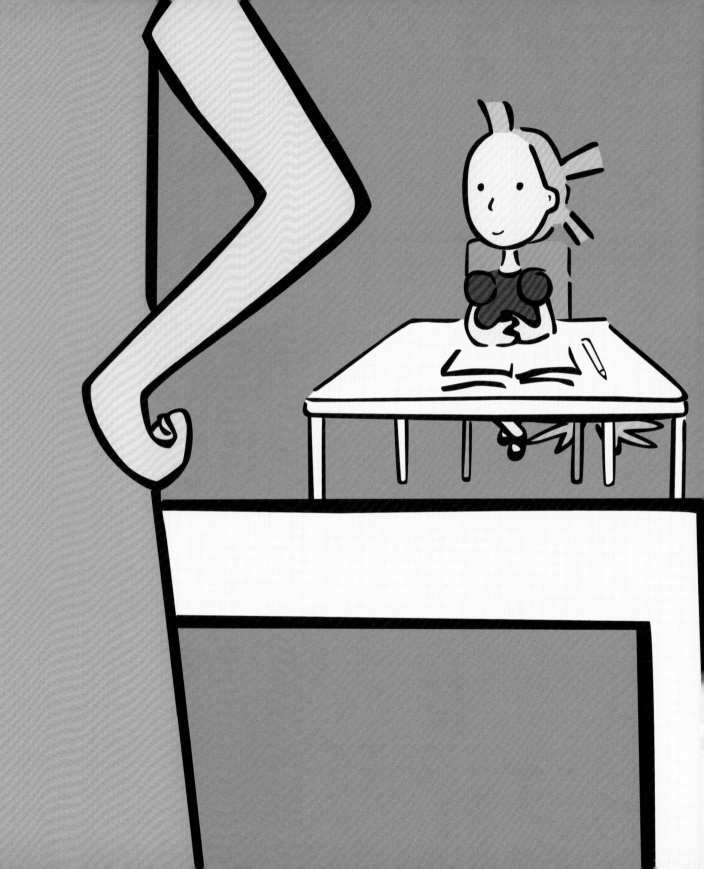

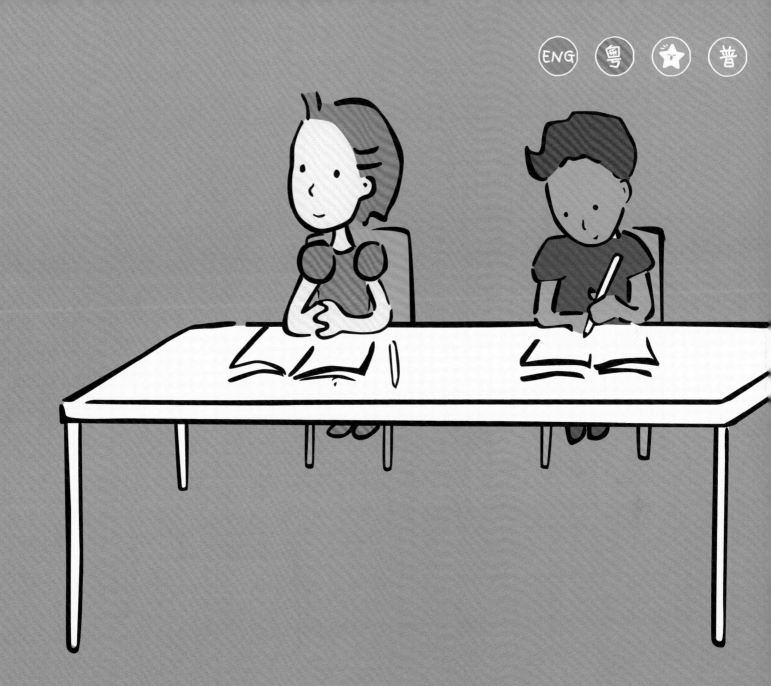

But when she turns around, she doesn't see Goose.

但她轉過身來的時候，卻看不見小菇。

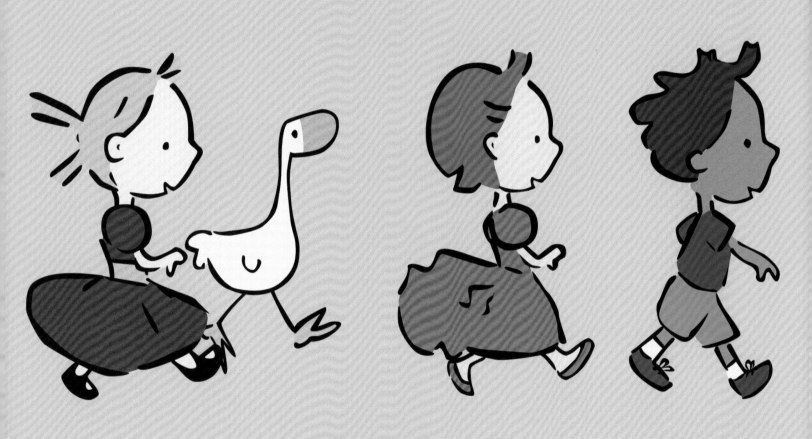

When the bell rings, everyone runs outside to play.

當下課的鐘聲響起，所有人都跑出去玩。

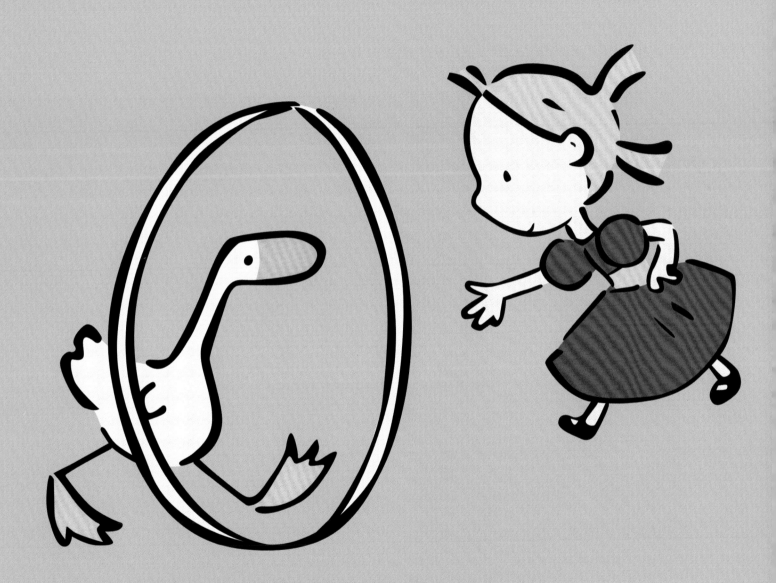

Sophie and Goose play games.

蘇菲也和小菇玩遊戲。

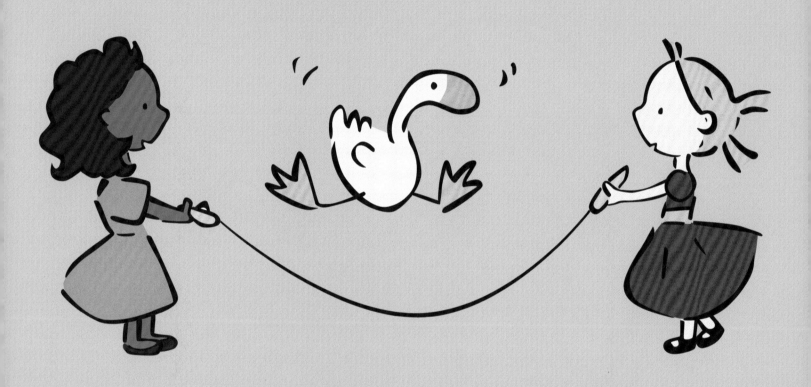

Soon, the other children want to play with Sophie and Goose, too.

不久，其他小朋友也想跟蘇菲和小菇一起玩。

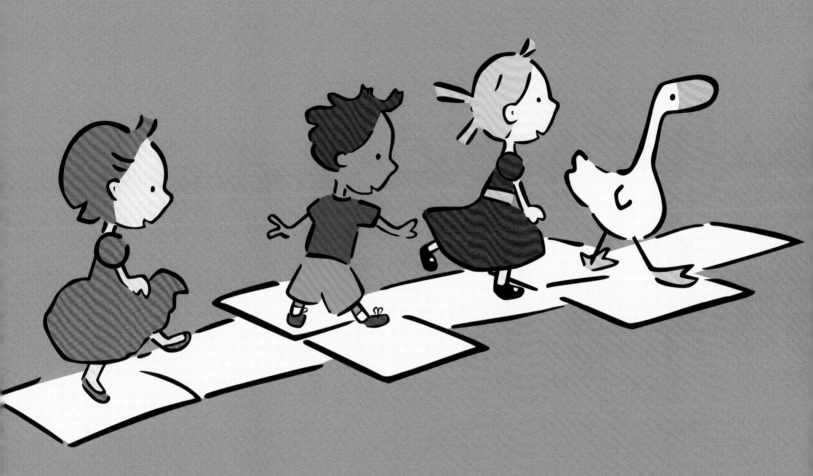

Playtime is so much fun with Goose.

有了小菇，遊戲時間好玩得多！

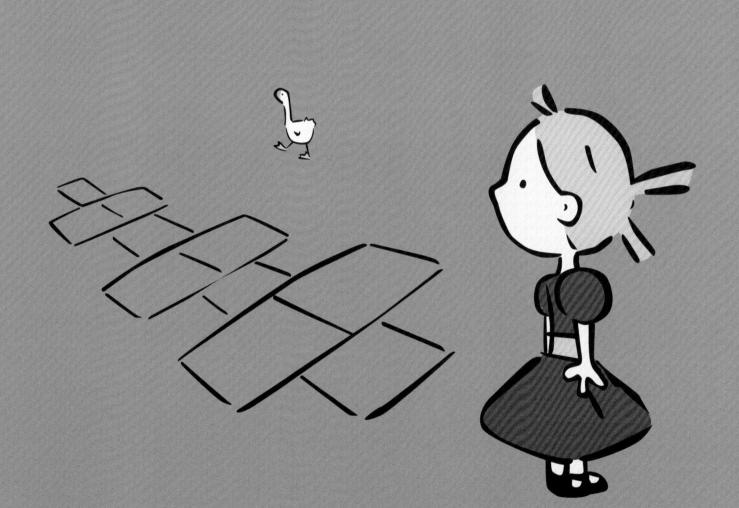

At the end of playtime...

遊戲時間結束了⋯⋯

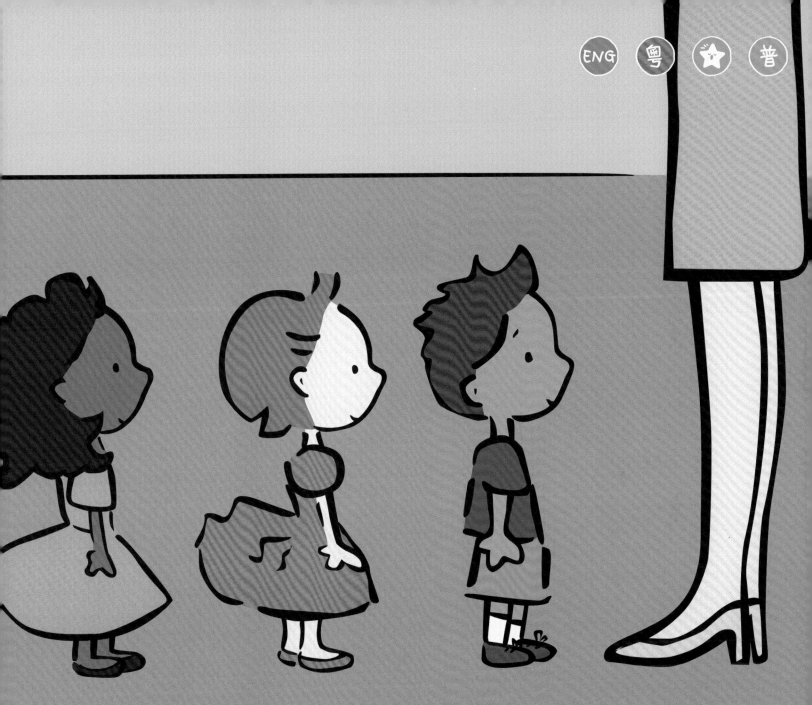

... Sophie goes back to class.

蘇菲要回到課室裏。

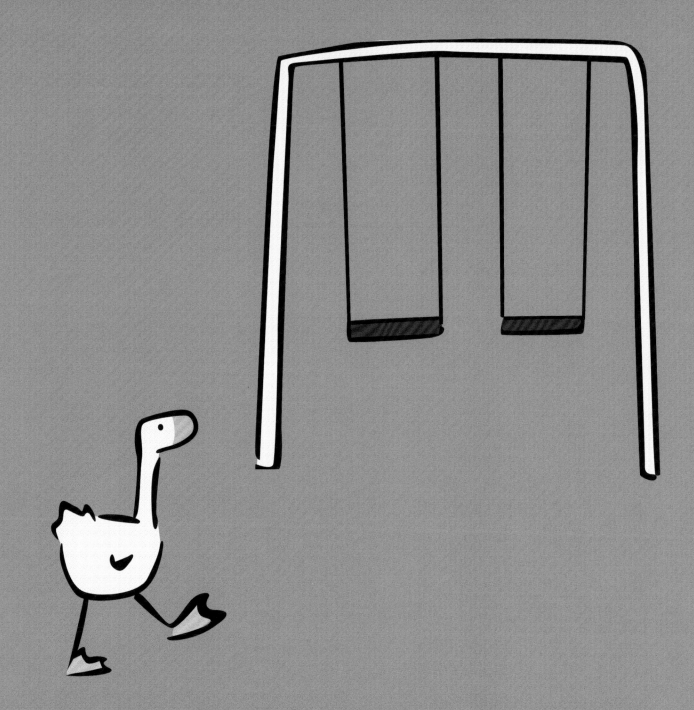

And Goose flaps off to play on the swings...

小菇拍拍翅膀，走去盪鞦韆……

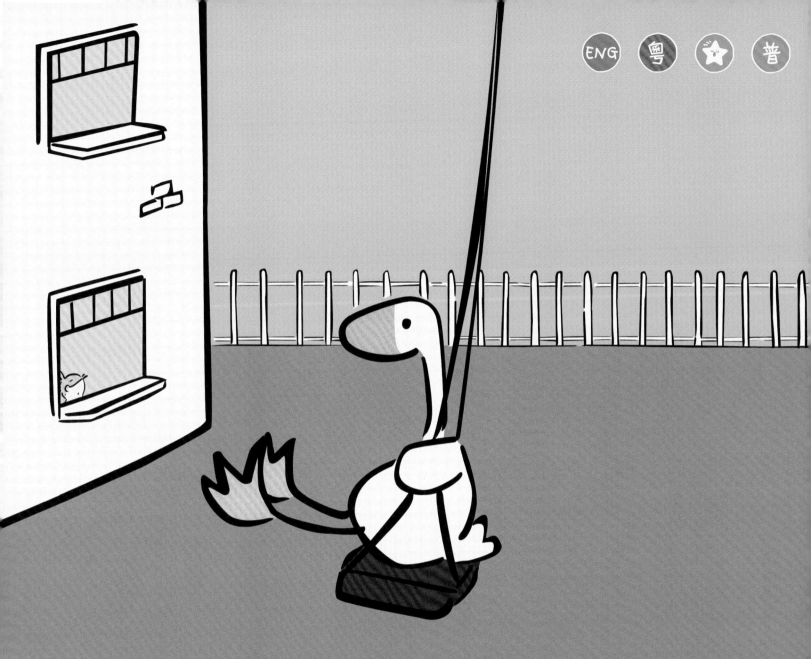

...and wait until school is over.

一直在那裏等蘇菲下課。

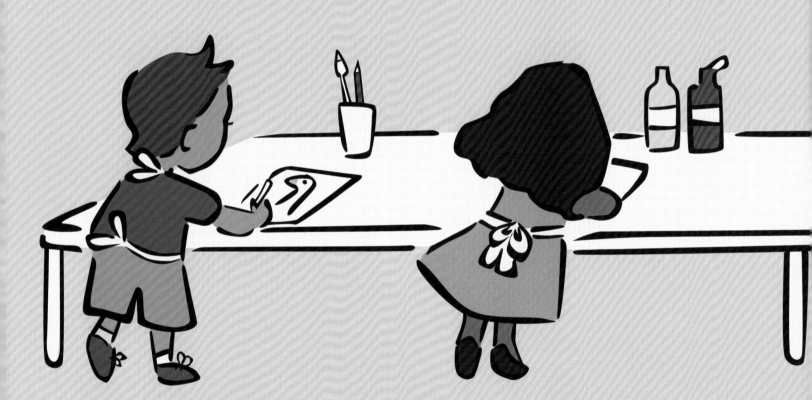

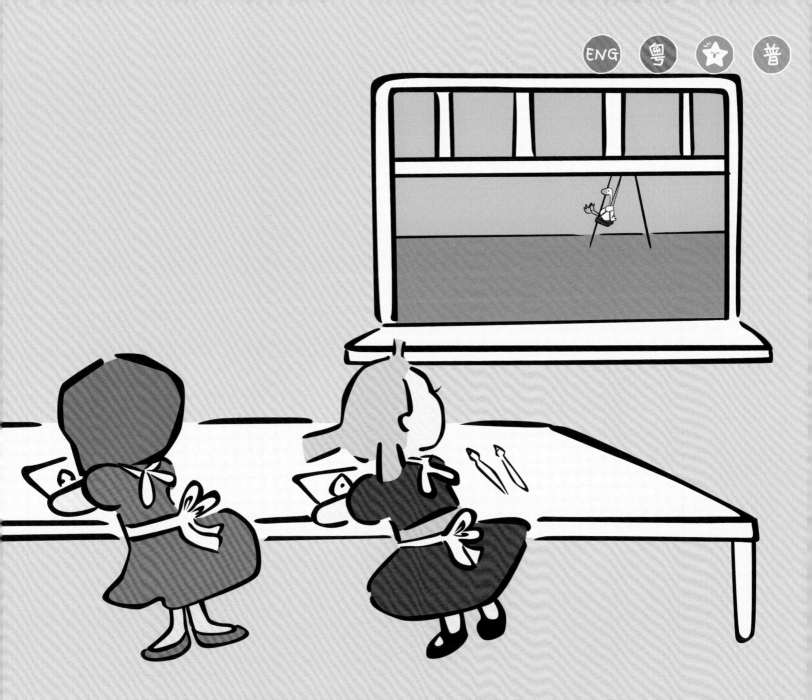

That afternoon everyone paints a picture.

當天下午，每位同學都畫了一幅畫。

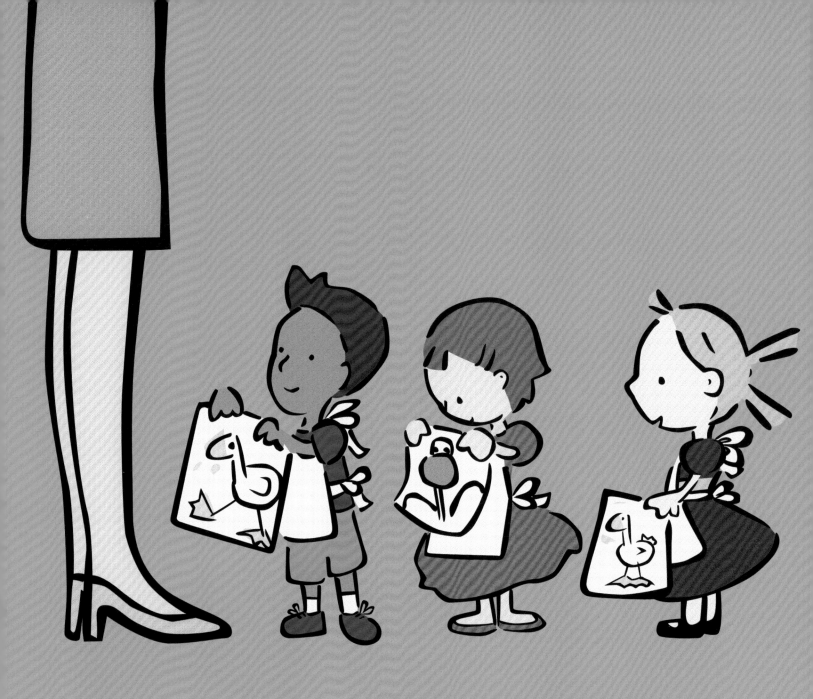

The teacher is very pleased with their paintings.

老師對他們的畫感到非常滿意，

40

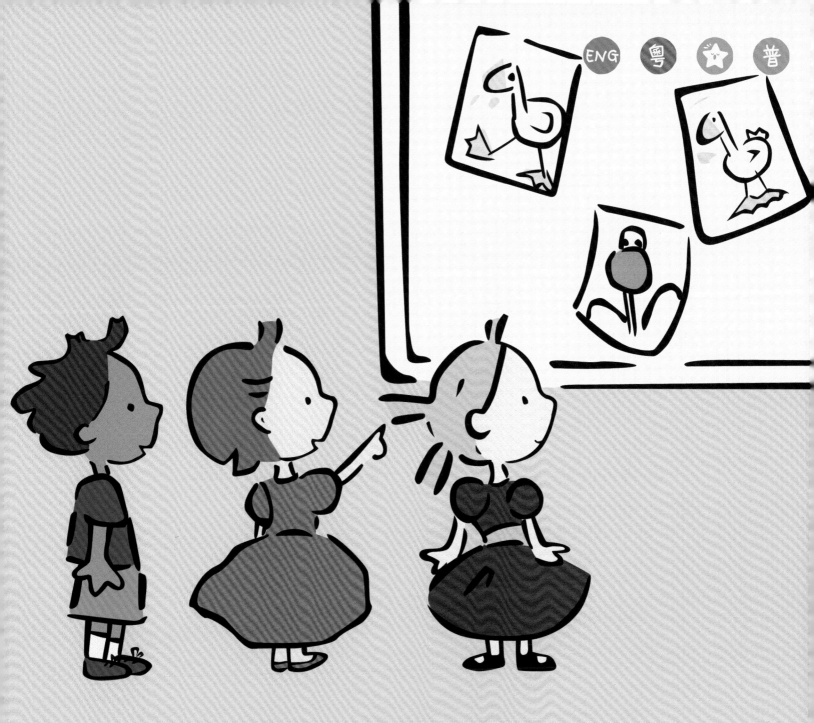

And she decorates the classroom wall.

還把它們貼在課室牆上呢！

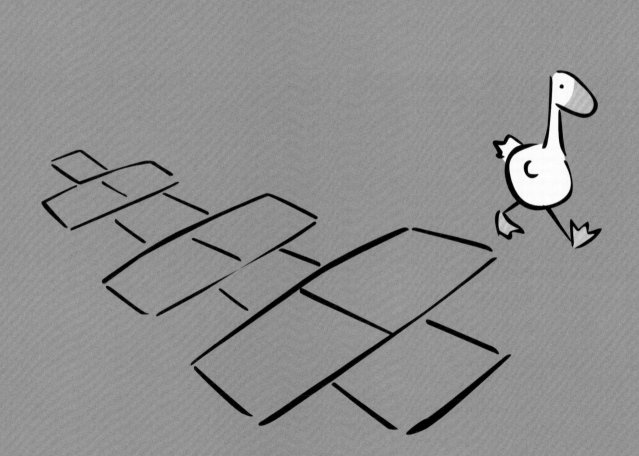

At hometime Sophie waits for Mum

放學的時候，蘇菲在外面等媽媽，

with her new friends.

身邊還有兩位新朋友。

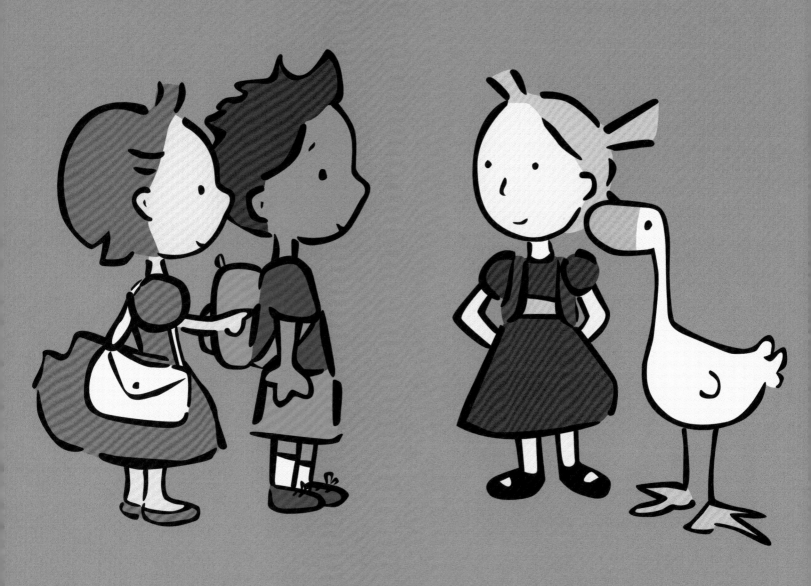

They ask if Goose will be back again tomorrow.

他們問她小菇明天會不會再來。

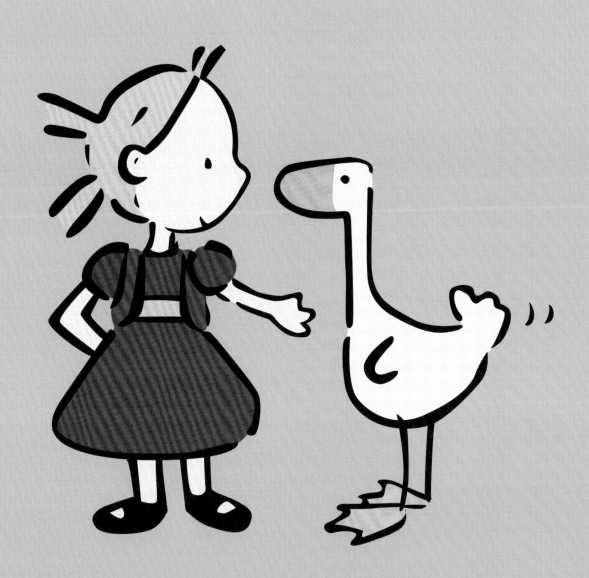

"What do you think, Goose?"

「小菇，你說呢？」

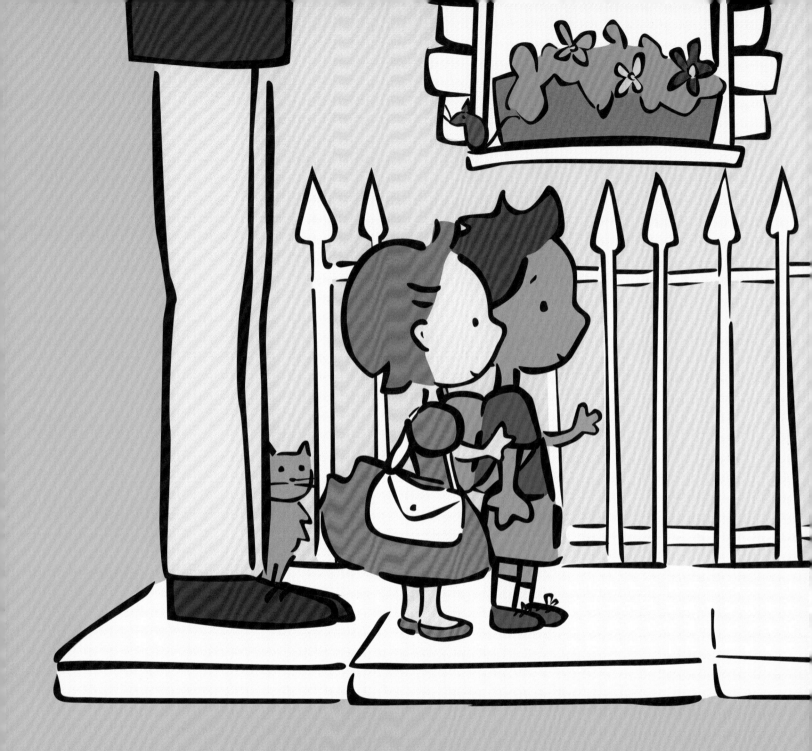

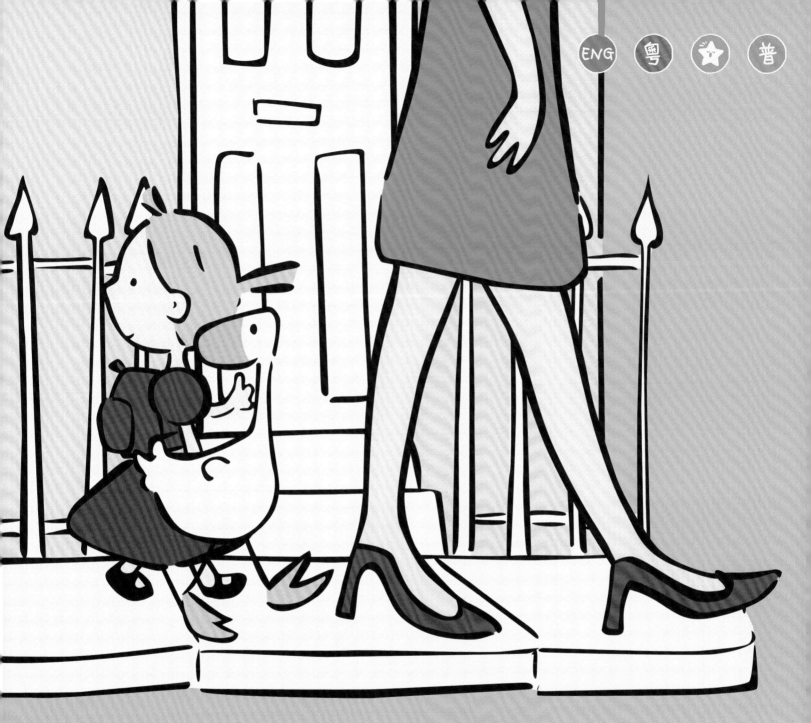

"Honk!" says Goose.

「呱！」小菇說。

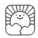

Goose 白鵝小菇故事系列
Goose Gose to School 白鵝小菇去上學

圖　　文：蘿拉·華爾（Laura Wall）
翻　　譯：潘心慧
責任編輯：黃偲雅
美術設計：張思婷
出　　版：新雅文化事業有限公司
　　　　　香港英皇道499號北角工業大廈18樓
　　　　　電話：（852）2138 7998
　　　　　傳真：（852）2597 4003
　　　　　網址：http://www.sunya.com.hk
　　　　　電郵：marketing@sunya.com.hk
發　　行：香港聯合書刊物流有限公司
　　　　　香港荃灣德士古道220-248號荃灣工業中心16樓
　　　　　電話：（852）2150 2100
　　　　　傳真：（852）2407 3062
　　　　　電郵：info@suplogistics.com.hk
印　　刷：中華商務彩色印刷有限公司
　　　　　香港新界大埔汀麗路36號
版　　次：二〇二三年五月初版

ISBN : 978-962-08-8150-3
Original published in English as 'Goose Goes to School'
© Award Publications Limited 2012
Traditional Chinese Edition © 2023 Sun Ya Publications (HK) Ltd.
18/F, North Point Industrial Building, 499 King's Road, Hong Kong
Published in Hong Kong SAR, China
Printed in China